WALK
WITH US

HOW THE WEST WING
CHANGED OUR LIVES

edited by
CLAIRE HANDSCOMBE

WALK WITH US
How *The West Wing* Changed Our Lives

Editor: Claire Handscombe

Cover Design: Kerry Ellis

Editorial Services and Interior Design:
Morning Rain Publishing Services

Publisher: CH Books

ISBN: 978-0-9975523-1-7

For Aaron Sorkin,
to whom I owe so very much

CONTENTS

Claire Handscombe

Not Just a TV Show

How **The West Wing** Changed Us
by Claire Handscombe

For one fan, it started like this: living in Japan, she was desperate for something in English to watch. Anything. The something she found lying around her apartment happened to be a box set of *West Wing* DVDs. A few moments in, she hit pause. "Did you *see* how long that shot was?" she asked her husband.

"It blew me away," she says now, speaking with awe.

It's been more than fifteen years since *The West Wing* first graced our screens. In 1999, we were worrying about the Millennium Bug, paying $700 for DVD players, and using pagers. When we talked about "the Congressional Facebook", it was without a hint of irony or any reference to a website that is now a ubiquitous part of life. 9/11 had yet to cast a shadow over the world and cause America to deeply re-evaluate its own identity.

And yet, the show continues to have an impact that is arguably unique. If you live or work in DC, references to it are inescapable. People have walked down the aisle to

the theme music. Or they've named children, pets, GPS systems, and even an iPhone app after the characters. Or they've started Twitter accounts as the characters to continue the storyline and comment on current political events. Or they credit it for closer relationships with their family members or a way out of depression.

The West Wing was unlike anything that had aired on television before. Witty, fast-paced, and intelligent, it followed the lives of White House staffers, in much the same way as, for example, *ER* follows the lives of doctors. Created by Aaron Sorkin, it refused to talk down to its viewers. Instead, the show drew them into a complex world that they often knew nothing about, and somehow made it mesmerising.

When Sarah McConnell[1] unwrapped her DVDs, half-way across the world, she fell in love. On some level, hers is a story that has been replicated time and time again down the years since *The West Wing*'s emblematic drum roll first began ringing out from our televisions. At the time, she loved her consulting work, but as she watched *The West Wing*, she became "insanely jealous" of the characters. Here were people who were competent, capable, driven, and incredibly human. They were who she wanted to be. She wanted more from life. She wanted to contribute to the world.

"I'm a lawyer," says Josh Lyman in one episode. "Everybody here's a lawyer." Something clicked in Sarah's brain. She, too, could get a law degree, and maybe one day work at the White House. She already had a Master's

1 "Sarah" requested that her name be changed.

degree and an MBA, as well as a (thankfully supportive) husband. It took her a few years to make the transition to law school, but she made it to the University of California, Davis, and as part of her studies was offered the chance to apply for an internship at the White House.

On Sarah's first day of orientation, the new interns were asked a question: "How many of you would say that *The West Wing* is your favourite show?" When only about a quarter of the people raised their hands, the orientation leader responded, "It used to be everybody."

"And I'll bet," Sarah says, "and this is just my speculation, that if you go now, that it's probably everybody again. But I was there at some weird in-between time." *The West Wing* had not been released on Netflix, and most White House interns—the majority in their early twenties—had been too young to watch it when it was on television.

By contrast, Jay Carney, the White House Press Secretary from 2011 to 2014, was in his early thirties when the show started airing in 1999. His tweet to Allison Janney, who played his fictional counterpart on *The West Wing*, delighted fellow fans. He welcomed her to Twitter, and asked if she would teach him to lip-sync "the Jackal", as she does in the show.

The flurry of Twitter excitement was possibly even greater in January 2014 when Jay Carney reunited two of the show's actors, Bradley Whitford and Joshua Malina, for a sketch to promote the White House's upcoming Big Block of Cheese Day, itself an idea taken from the show. In 1837, President Andrew Jackson published an official invitation for the masses to drop by for a piece of a 1400-pound block of cheese and to mingle with high-level officials. In the spirit of this, from time to time, Aaron

Sorkin's White House opened its doors to ordinary people with questions to ask and projects for which to lobby, like a wolves-only highway, or a switch to the Peters Projection map, which provides a more correct understanding of the size of countries relative to each other.

The West Wing taught its viewers things of political and social importance, like the relative size of those countries. Even without the retrospect from which we now benefit, people knew of the show's effectiveness when it came to getting a message across. In an interview at Cambridge University in 2013, Bradley Whitford—who won an Emmy for his portrayal of the brilliant and wounded Deputy Chief of Staff, Josh Lyman—explained, "I would get lobbied by lobbyists when I went to Washington. They wanted to get their particular issues on the show because we could get twenty-one million people to watch a forty-six-minute show where you went through, basically, the pros and cons of whether or not the decennial census should be done by actual polling or computer modelling." He added with his trademark dimpled grin, "And, you know, Rob Lowe got laid." In other words, it was entertaining too. Not to mention aesthetically pleasing.

So the show taught us. It inspired us. But it impacted us in other ways, too. On Twitter, viewers are eager to share their experiences of how the show has changed their lives. "I chose to become a US citizen rather than remain a resident alien," wrote one. "I wanted to participate." Another responded, "Knowledge of US politics based solely on WW helped me bluff my way through my Oxford interview." Another claimed to quote from it daily. Someone posted a picture of his to-do list: to motivate himself, he added "What's next?" at the top—a catchphrase imbued with something like majestic significance as used by the fictional President Bartlet.

Juli Weiner's 2012 article for *Vanity Fair*, "West Wing Babies", refers to Josh Lyman as the archetypal role model

for wannabe super-staffers. But there are countless other role models in the show, too. Referring to a Republican who is drafted into Sorkin's Democratic White House, someone tweeted, "Ainsley Hayes made me want to engage in debate, rather than just shout at people who have different political or economic views". And Sam Seaborn, the young Communications Director played by Rob Lowe, has also had a profound influence on fans.

Jan Sonneveld, for example, is a high-level speechwriter in the Dutch government. "It puts the idealism back into what you're doing," he says of the show. He draws comfort from it, too. Late in the first season, Sam Seaborn forgets to change the opening of a speech which has been moved indoors due to inclement weather. The President, speaking within four walls, begins, "As I look out on this magnificent vista…"

Jan notes that those "kinds of mistake are the mistakes I make. In that way it resembles real life." On another occasion, when Sam has written a moving speech after pipe bombs explode in a school, one of the characters asks him when he wrote the last part. "In the car," he responds, and that, too, Jan appreciates. He says that it's in the "most crowded, most stupid busy moments you have to write the most powerful stuff".

I asked Jan what he thought made the show so appealing. "It was the right series at the right moment," he says. "It put the idealism back into a decade with negative views." A similar opinion was expressed by David Burstein, who at the time of writing was twenty-five and the CEO and Co-Founder of Run for America, an initiative to bring a new generation of talent into the American political system. He says that *The West Wing* showed cynical people that "there was something in politics that was worth engaging in, that was worth fighting for, that was worth being part of." He goes on to say, "It stands alone among television shows, in that it actually had real meaningful impact on

our nation." *The West Wing* fed his interest in politics as he grew up and went through college. It was "a place where he could go to meditate on politics" and importantly was also the catalyst for "social experiences with my friends around politics".

That social aspect is an important one, too. Jennifer O'Neil, who works on the Hill as a Scheduler to a Republican Senator, says that "if you're at any kind of Capitol Hill happy hour, reception, gathering, there's gonna be a West Wing reference, and everybody's gonna get it".

Jennifer also says that without the show, she wouldn't be doing what she is doing now. She grew up watching it with her family; she, her brother and her parents would buy each other the various seasons for Christmas and birthdays and bundle onto the couch to share the experience. "It just really inspired a lot of dialogue and conversations between all of us. We ended up having these smart political conversations about some of it and about public service that I don't think would have happened without the show." When her school offered the opportunity to study in DC for a semester, she eagerly took it, which she says she would have had "zero interest in" were it not for *The West Wing*. This was the move that set the direction of her future career.

As for Sarah, her internship was everything she had dreamed it would be. "I got to live out my fantasy," she says. She loved the work, and when she was occasionally given less interesting tasks, she'd remind herself that "working at the White House makes you feel better about life. Because you're not just doing this for anybody. You're doing this for the President of the United States." For extra motivation, when it came to getting up in the morning, she had *The West Wing*'s theme tune set up as her alarm. "It was so much more like *The West Wing* than I thought it would really be," she said. "The White House

really was filled with incredibly, incredibly smart people. You know the way that Sorkin writes—people just have facts at their hands… The White House is seriously filled with people who can talk like that."

On one occasion, a person for whom she had written a memo didn't have time to read it. "Can you walk with me to my next meeting and tell me about it?" this person asked, a line that could have come straight from the show. Now, when Sarah rewatches *The West Wing*—as fans do, over and over again—and there are exterior shots, she thinks, "I worked there. I did that. I can feel happy all over again."

Much as she would love to, she doesn't think she'll ever get to go back, though. Her priorities have changed; after years of trying, she got pregnant as soon as she left the White House. "I had given up. And then, I don't know, I was just so happy after working at the White House I got pregnant." That's unprovable, of course, but is it so hard to believe that a show that has changed so many lives could also, in part, be responsible for starting another?

THE WEST WING CHANGED HOW WE SEE OURSELVES

Rather than changing me, I think *The West Wing* helped give me permission to be myself as a young, passionate, and opinionated woman. It reminded me that power is service. The kind of power which has a positive impact on communities comes from serving others first and focussing on improving their lives, regardless of their background. The best leaders have always known this.

Cathryn Stephens, 35, Melbourne, Australia, teacher

There wasn't a character like CJ on TV, and there wasn't an actress like Allison. With CJ, it became ok to be a strong female in a male-dominated field and struggle with being heard, being taken seriously, and finding your voice. She also never apologized for what she believed in or fought for. On the flip side, she was a very human character with flaws, mistakes, and craziness—and she survived it all. She was the feminist I wanted to be, and a character I identified with and continue to. The passion she brought to all her work is something I see in myself. *The West Wing* taught me to be me.

Colleen Harris, 37, Seattle, WA, digital marketing

Phil and Helen Kornick were big fans of *The American President*, so they started watching The West Wing from the beginning. Their twelve-year-old daughter, Heather, would watch with them and ask questions until eventually they asked her to write them down and save them for the end. (Their son, Aaron, was under no illusions: "It's not like I counted during that hour, unless I was bleeding.") Heather fell in love with Josh Lyman: he was quick and smart, the kind of boyfriend she wanted. Boys didn't talk about real things the way Josh did.

Although she was always looking for Josh, Heather wanted to write like Sam. She went on to study Political Science and Religious Studies and took the opportunity to put her writing skills into practice even before that. As regional VP in her youth group movement, she had speeches to make. She would revise and revise them. "It's not done until you give the speech," she would tell her parents.

When Heather was diagnosed with cancer in the week after her twenty-first birthday, people around her didn't realise how serious it was. "You've gotta spin," she would say, "because nobody wants to hear Debbie Downer news." When she passed away almost five years later, she left her parents a to-do list, and Phil and Heather are now heavily involved in philanthropy and fundraising on her behalf with organisations such as Relay For Life.

Though Heather passed away before fulfilling her dreams, her mother, Helen, notes that she "was an excellent speechwriter in her own right. *West Wing* characters were her role models and her inspiration."

"You Just Want To Share It All With Someone, You Know?"

Reflections from the Edge of the Cliff
by Erica Harmon

The crowd gathered on the mall, silenced with anticipation. The results were in. My name was called in triumph. I would be serving as my university's student government secretary for the next year, making it the second executive position I would hold: first Chief of Staff, then Secretary. "We should start calling you C.J.," a friend of mine said to me.

"Who's C.J.?" I replied.

I decided to watch *The West Wing* a year later, when my tenure in student government came to an end. Friends (good ones) had been trying to talk me into viewing marathons of the show for years. I finally gave in when I needed something to play in the background as I sent out my résumé to dozens of potential employers during my senior year of college.

As I was a young female professional, it should come as no surprise that the character I became attached to early on was C.J. Cregg. From the beginning, her charm and grace under pressure were easy to fall in love with; her courage in the face of her loneliness as a successful woman in a man's world was far more admirable still.

"I want to be the White House Press Secretary someday," I declared firmly to my parents, not long after finishing my first run-through. They looked at me with a discreet pity reserved for children who should have long outgrown their fairy tales. "Oh honey, no, you don't want that kind of pressure," they said.

They were right. I knew within hours of saying it out loud that being the White House Press Secretary was not my dream. But what was it? What was my draw to this world?

———— WW ————

From 2011 to 2015, I watched the show four times through in its entirety—averaging one marathon per year. During the first run-through, I convinced myself that my opinion of the entire show was going to be determined by the outcome of Josh and Donna's relationship. It took a lot of patience, and confessedly it was more or less a trivial reason on which to base my opinion of the entire show, but it paid off. My affections had been bought. The second time, however, I paid closer attention to the other relationships—friendly, romantic, professional, or otherwise ("Gerald!")—and how each one was equally special and important. The third time around was dedicated to understanding plot lines better, especially if they involved complicated military operations or political

maneuvering. The fourth, and most recent time, however, was a reflection of how I had changed in the past four years in relation to these characters, who had not. I had already accomplished personal dreams, such as moving to New York City. I had traveled, held a good job, tried new hobbies and experiences. I had a loving family and a great network of supportive friends, but there comes a time when you realize that you walk alone in the end, no matter how much you try to prevent it.

For the fourth time, I came across C.J.'s monologue in *Faith Based Initiative*—the one in which she begins by definitively declaring her heterosexuality to Leo, then moves into a brief recap of how she has been let down by the opposite sex throughout her life. She concludes it by stating how nice it would be to just share her experiences and successes with someone. "You just want someone to share it with, you know?" Allison Janney says while the camera cuts to Leo McGarry, played by the brilliant John Spencer, who is wishing he could have been in any other room at that moment. Sharing—such a simple, kindergarten lesson, but oh, such power it holds.

That's what I was feeling, I realized. A lack of shared experience. And not just in the form of a romantic relationship, but the experience of sharing a goal with someone else. Here I was, four years after my first time watching the show. Almost four years after graduating college and moving to a city where I knew no one, and what was I doing there? What was my purpose? Where was my team, and what was our grand calling? Graduation had stripped me of a safety net of friends and a predetermined life trajectory. I had been hanging over the edge of the cliff that so many people were willing to jump off for President Bartlet, but I was completely

unsure if it was, in fact, the fall that was gonna kill me. What was waiting at the bottom for me? I still don't have the answer to that question, but what I found in *The West Wing* was motivation—motivation to work harder, to continue growing intellectually, and to keep asking questions. I realized that before I could find my own team with a set of shared goals to work toward, I needed to figure out what those goals were for myself, just as each character in the show needed to figure out their role and purpose in the Bartlet Administration that would make all the puzzle pieces fit, as we saw in the opening two-part episode of Season Two, *In The Shadow of Two Gunmen*. I felt comforted knowing that life does not begin in the second year of a presidency. That everyone starts from a place of uncertainty, and that's okay. From there, I knew what I had to do. C.J. needed a hero, so she became one herself.

For me, the wisdom of *The West Wing* is found in each and every member of the cosmically-divined ensemble. These characters are friends when I need them to be friends. They are teachers when I need them to be teachers. And they are heroes when I need them to be heroes. For all their mistakes and missteps, they become more alive and relatable and real as I get older. They don't have magical powers, but they are led by good intentions, empathy, and understanding, which are magical in their own right. Their demons hold magic, too. From the shadow of death that follows Josh Lyman, to Leo's alcoholism, the President's shaken faith, the loneliness of C.J. Cregg's success, and Charlie's struggle of growing up in an insidiously discriminate society—we don't just observe, we absorb. We relate.

———————— WW ————————

It is also my belief that *The West Wing* has enjoyed overwhelming public popularity due, in part, to its ability to balance intellect with emotion; a balance which is packaged and shared gracefully with its audience. Arguably, some of the show's best episodes deal, to a large extent, with the characters' emotional trauma, rather than solely with politics or affairs of state. Think *Two Cathedrals* ("You get Hoynes"), *In Excelsis Deo* ("I just miss my boys"), *Noël* ("...yeah but I've been down here before, and I know the way out"), *The Crackpots and These Women* ("...And for all the other times, I just want to be able to look them in the eye..."), *17 People* ("If you were in an accident, I wouldn't stop for red lights") or *Posse Comitatus* ("Crime, boy I don't know, was when I decided to kick your ass"). These were episodes in which the main storylines focused on the emotional well-being of our characters, and ultimately served to show how their morals and emotions fueled their heavy decisions. The moral integrity of the entire show was epitomized by Martin Sheen's performance in *Two Cathedrals*. He questioned his belief system—his entire moral foundation—and became a stronger leader in the end.

Aside from trials and teammates in our personal lives, we are also able to relate to *The West Wing* in another unique way: a shared history. Josiah Bartlet is as real to us as George Washington or Abraham Lincoln[2]. We are taught about heroism through stories of people who took

―――――――――

2 By this analogy, I am in no way demeaning the very real sacrifices these men made for our country, but only to draw the similarity that George Washington and Josiah Bartlet both live in the minds of everyone who is alive today through the same way— storytelling.

up the torch and found they could carry it well. They are meant to be figures of valor and nobility, but like any other human beings, they were all inherently flawed. Moments of patriotism in the show connect with its American audience. You feel it in those moments, such as when Sam explains to Donna that "this country is an idea, and one that has lit the world for the last two centuries." Or every time Leo gave his "Big Block of Cheese" speech. And if you say you didn't cry when President Bartlet gave Charlie his family's carving knives made by Paul Revere, I don't believe you.

We relate to the political, religious, social, philosophical, and psychological ideals of these characters, our own emotions ebbing and flowing with their triumphs and failures, because we project ourselves onto them. For me, Jed and Abbey Bartlet are second parents. Leo is my wise uncle. C.J. is my quirky wing-woman. Josh, Toby, Sam, Will, Charlie, and Danny are my valiant gentlemen. Aaron Sorkin and his team of writers presented their audience with precious gifts: to be able to *think* and to *feel* while watching television. To improve relationships with ourselves through fictional holograms. To create something tangible out of something imaginary.

The West Wing is the American fairy tale, and we are drawn to its knights because we can see our reflections gleaming from their tarnished armor. We want to be seen, we want to connect, and we want to be part of something greater than ourselves. We want to *share* our experiences, whether they be in the form of goals, values, ideals, emotional trials, or simply our histories. We ambush our friends so that they may discover this magic, too. We say to them, look at this thing: this beautiful thing that I have found. Look and be amazed at how it has inspired me. Don't you feel that, too? A flicker. A spark.

———— WW ————

I have made no drastic life changes as a result of *The West Wing*. But I do feel less alone. I do feel more understood. I have laughed a little more and cried a little more. I have felt real emotions and have learned more about myself and what I want. Thinking that I wish I could have Sam's unrelenting idealism and writing ability. I wish I could have C.J.'s disarming charm under pressure. I wish I could find my own Josh Lyman or Danny Concannon. The show helped me focus on what mattered, and it gave me goals to work toward.

Working at the White House and being the Press Secretary or the Chief of Staff is not my fantasy. Rather, I long to feel that camaraderie with people who are pushing ahead in the same direction toward a shared dream, fueled by a noble pursuit: to serve others. And in the meantime, it's nice to be able to remind myself that once upon a time, Josh Lyman worked for Senator John Hoynes, Sam Seaborn worked for a law firm defending insurance companies, C.J. Cregg worked for a PR firm with hot-headed media clients, and Toby Ziegler had never won an election. And it was all okay.

I found some truth about myself and humanity through this work of fiction, and in the end, isn't that the ultimate success of fiction?

C.J., Leo, Toby, Josh, Sam, Will, Charlie, Amy, Donna, Joey, Ainsley, Abby, and Josiah Bartlet will be part of me for the rest of my life. They came into my life right when I was about to get pushed off the cliff—to move to New York City where I knew nothing and no one; to begin adulthood, dependent of prescribed direction. I felt

excited, frightened, and desperately alone but hopeful, staring into the existential abyss of the future. And quite honestly, I still do.

Over four years ago, I took a deep breath and jumped. *The West Wing* has been holding my hand on the way down ever since.

THE WEST WING CHANGED
OUR ROMANTIC RELATIONSHIPS

In October 2014, I agreed to go on date with a cute, charming, and politically-inclined young man whose last name just happened to be Bartlett. And, yes, given that I was a *West Wing* nerd, his last name (with an extra T) may have pushed me over the edge in convincing me to give him my number. Our first date was a great success as we discussed international trade policy over steak and pasta. Every other date happened to be a success too. I married him this past March.

Shea Bartlett, 24, Washington, DC, Arts
Administration

————— WW —————

Dave and I met on the Internet, on something called a newsgroup or Usenet. Back when the Interwebs Was Young, folks liked to talk to each other about their favorite subjects, just as they do now, but there was no Facebook, no Twitter, no blogs, no websites as we know them today. Just text. Via newsgroups, you could post about your favorite topics, shows, and what have you. Back in the day, there was nothing for a couple of fans of *The West Wing* to do but lurk around the "alt.tv.the-west-wing newsgroup" in order to get their weekly post-episode fix. I used to post weekly recaps, called "Random Thoughts",

after every episode. Dave used to read them. One day, he contacted me via email. He asked to borrow some videotapes I had, of past episodes. I let him, (I confess, a little reluctantly—I hate lending my stuff) and we started emailing each other. Soon, we started calling each other, too. And then, for about ten years, we emailed, called, and eventually texted each other, a lot.

Yes, I said ten years. I looked forward to those emails every day, and I loved talking to him for hours. The years went by and nothing changed, and then one day in 2010 I realized that he was my favorite person in the world to talk to. That I loved the sound of his voice. That I missed him when he was away, or busy. That I was jealous of the idea of him being with another girl. I told my best friend, Tom, and he pointed out the obvious: I had feelings for this guy, and I needed to do something about it. He was right. So about a month later, I did.

Dave was pretty dense and didn't get what I was trying to say to him until I'd hit him over the head with it, but he came around fast when he did. A few weeks later we saw each other for the first time, and by the end of that day I knew I wanted to love him forever. Luckily, I gather he felt the same.

We've been married since November 2013. My husband and I love *The West Wing* and still rewatch episodes all the time, though we can quote much of them from memory. (We slaughtered the room at a recent *West Wing* trivia contest). It's a common language for us, and it's what brought us together. We sent Aaron Sorkin an invitation to the wedding, though we weren't offended that he didn't reply.

Toni, 44, New York, writer and blogger

NEW YORK MINUTE
by Jenny Moore

I don't remember what I was wearing that night, but I know he wore a blue shirt that highlighted his eyes. We met at the Manhattan apartment of mutual friends, six of us in all, to watch the season premiere. Our hosts were an engaged couple, golden and both distracted throughout the show, bringing in chairs, up and down for drinks and food. I hadn't met the others. There was a single guy who sat in the most comfortable chair as if he owned it. And one other couple. At least, they were a man and woman who arrived together and he introduced her to everyone. Only a vague picture comes to mind when I try to recall the woman, but I won't forget the man in the blue shirt. I married him.

I discovered *The West Wing* in its second season. Since the premiere, I'd been hearing that people liked it, but I was in my twenties, living in New York City, and not always home at nine on Wednesdays to watch. (VCRs were out of style; TiVo was out of my price range.) When I finally saw an episode, I realized it was no ordinary show.

The West Wing made government meetings exciting, bipartisan compromise a noble satisfaction, and reasoned debate on the issues downright sexy. This was a show that upheld ideals and then put them within reach, without being syrupy or compromising complexity or ambiguity.

The show's White House looked like the way things should be—could be, even. In the early 2000s that seemed more important than ever. It was political candy like I'd never seen before.

I was at the Manhattan apartment because I couldn't watch at my place in Brooklyn. I no longer had any television reception. I didn't pay for cable. The antenna on top of my TV had worked well enough when it could get a signal just across the river from the highest antenna around, the one at the top of the World Trade Center. But a month earlier that antenna, along with so much else, had crumbled to dust.

The scheduled premiere date had been pushed back a week, to October 10, 2001, to make room for a hastily created special episode directly addressing terrorism, which aired a week earlier. I watched that one from my father's living room in the suburbs of Washington, DC. I'd been visiting in the middle of the workweek because I had lost my job—I'd been laid off exactly two weeks after the towers fell, my employer a casualty of the cratered economy.

That trip home to DC was my second since 9/11, a day when my father had been at work, shuttling between his boss's offices in the Capitol and in one of the Senate buildings. One of the first things I'd heard on that clear morning, as I stood twenty blocks north of Wall Street and stared at the gaping burning holes in both towers, was that there was a fourth plane that couldn't be located, and it was believed to be headed for Washington. I was feeling the urge to go visit my dad more often.

———— WW ————

Before *The West Wing*, I felt allergic to politics. I claimed it was because I'd grown up in DC, as if that built up an immunity, though several of my school friends had been certain, even as teenagers, of their futures on Capitol Hill.

When I was three and my parents were divorcing, my father took a domestic policy job in the West Wing. He worked fourteen-hour days on weekdays, nine-hour days on Saturdays, and a handful of hours as needed on Sundays. I only have sense memories of that time, of the strangeness of being picked up by him at the house we used to live in together, of the unfamiliarity of his new apartment, of the disagreeable taste of the first unsuccessful meals he cooked for us. We attended one White House Christmas party in that era. Family lore has it that I didn't like the cookies on offer and lay down in front of the string quartet in the Grand Foyer and screamed, the only tantrum anyone remembers me ever having.

Politics was a part of the mechanism of my family life. It was what my father did then—he was a legislative director in the Senate during most of my childhood—and the way the Hill worked affected the way my family worked. If there was a Senate vote, for example, any plans with my father were delayed or sometimes canceled. Politics meant I did a lot of waiting around. And if my dad was late to pick up my brother and me at our mom's house, it meant we had even less time with him.

Growing up, I was never interested in how politics worked. I was interested in what it took away from me. After 9/11, my aversion corrected itself. I began to feel the impact of the choices elected officials made. I began to watch the *The West Wing* every week.

October 2001 in New York City: everything was in a state of suspension. Some of the city—that is, the parts that had been least affected by loss and grief—was starting to resemble itself again. Sort of. Those people who still had jobs went to work. Clean-up at Ground Zero was underway. Yet Lower Manhattan was guarded by camo-clad soldiers with hulking guns. The city's pace was subdued, the markets down. The subways weren't full, and the people riding them were hypervigilant, more wary of unusual sounds or delays. Everyone was on edge and wounded in some way.

I was skittish as I tried to find a new normal. My unemployment checks had started to arrive. I was job-searching and trying to appreciate my office-free days. I did my best to be social when I could, even when it meant going alone to the apartment of people I didn't know very well to watch television.

I was new to this group, a friend of a friend of our female host. I'd only met her a few times, and though she was welcoming, the others seemed so familiar with each other it was hard not to feel self-conscious. They had stories of ski weekends and referred to various jokes involving absent people. Even the way they debated the merits of their usual take-out restaurants highlighted their intimacy. I was glad to be included and eager to watch the original season premiere, created months ago before everything had changed. One more step toward normal.

The people on *The West Wing* slept little. They had disastrous personal lives. Their dates and vacations were

often canceled, their intimacies interrupted. But they had jobs unlike any I'd ever known—the exhaustion didn't matter because the thrill never faded. Just being at work provided a rush, every day. Was this how my father had felt? I hadn't thought much about how exciting such a job would be. The characters were imperfect, human, forgivable, and still they were in the seat of power making a difference. Their collective brainpower operated as one formidable organism. Their infectious familiarity and shared wry humor beckoned me into the rooms of their inside jokes. I wanted to know them, work with them, be them.

The man in the blue shirt and I chatted during commercial breaks. He was easy to talk to. His companion barely said a word. At the second commercial I told myself to back off, give her space to participate. I assumed they were on a date. Yet, when he spoke she didn't say anything. When anyone spoke she didn't say anything. And when he talked I had something to say—so I kept answering.

He was smart, funny, and seemed completely at ease. We kept finding connections. He told me he loved DC, that he had lost a job after 9/11 too. Our apartments were just a few blocks from each other on the rougher, cheaper edge of an increasingly hip neighborhood.

Had he not arrived with her, I would have suggested we walk together to the subway or share a taxi to Brooklyn. I wanted to keep the conversation going. Instead I waited for them to leave before I walked to the subway alone.

Before 9/11, *The West Wing* was a show about a presidential administration that was better than our actual one. Something to hope for. Watching now, some storylines seem quaint. The president embarrasses the vice president in a cabinet meeting. The First Daughter is annoyed by her security detail. A powerful fundraiser in Hollywood attempts to manipulate the president. The staff works to protect the dignity of an aging senator who filibusters in a foolhardy, but deeply personal, attempt to add modest funding to a health bill. The technology is quaint, too. Everyone carries beepers, and email, though common, is only used when sitting in front of a desktop computer. It doesn't seem ancient, just a reminder that we all used to do things differently. When I started watching the show in 2001 I had no cell phone and used a dial-up modem to check email at home.

After 9/11, *The West Wing* was still a Democrat's pipe dream but the stakes were higher. The tone shifted, and storylines took on somber and lasting topics more often— the parallel universe mirroring what was happening in reality. In the finale of Season Three, for example, the President is pushed to order the assassination of a terrorist leader. Though it will prevent the deaths of many unknown people, it's an agonizing choice, steeped in moral ambiguity and personal torment—but still relatively clean, in hour-long-TV-drama style. On the show there were no dubious invasions, no drawn-out military actions, no bloody chaos.

When the U.S. began combat operations in Afghanistan in October 7, 2001, I could not shake a sinking feeling that my country was headed for very shaky ground. I'd watched the news in an empty midtown office building where a friend had hooked me up with a weekend temp

job babysitting some servers for a tech company. I called my family with my new cell phone. At midnight, when my shift was over, I emerged from the building onto a dark shuttered street in an unfamiliar neighborhood. Going home to my apartment was hardly solace. The last month had effectively dismissed me from my carefree independent twenties, and my solitude no longer seemed to be a source of strength.

If I hadn't met the man in the blue shirt on October 10, 2001, maybe I would have met someone else or moved away. Or I might have met him another night and gotten a different impression. It's likely we would have crossed paths at some point—like the time we next saw each other at a brunch—but it might not have unfolded the same way. He might not have arrived late to that brunch and sat down in the only empty chair, next to me, and then we might not have cracked each other up during the whole meal. Maybe we wouldn't have begun to finish each other's sentences. Maybe we wouldn't have decided to go see a movie after brunch. Maybe, after the movie, we wouldn't have chosen to spend the whole day together. If all of those things had not happened, maybe I wouldn't have fallen for him—a blue-eyed Catholic from New England who had gone out into the world and made something of himself.

I can wonder forever about what might be different if I had skipped *The West Wing* that night.

The West Wing's president, Josiah Bartlet, was another blue-eyed Catholic from New England who had gone out into the world and made something of himself. From the beginning, he seemed like a fantasy. He said what he meant and always said it right—and he found a way to make good on his word. His brilliant, agile mind stored and recalled obscure facts as easily as he fulfilled weighty tasks with care and profundity. Sure, he had enemies, but he found ingenious ways to show them the benefit of *his* way, which was always better and more judicious, more right. Even his difficult choices were humanly and ethically defensible. The man had surrounded himself with brilliant people, and he knew how to lead them.

His personal life was commendable too. He was in love with his wife and was an adoring and protective father. Loyal, especially to his alma mater and his home state. He was deeply, but inoffensively, religious and could win a Bible smackdown with self-righteous religious conservatives. For fun, he spouted Latin and dissected economic policy. He was undeniably cool.

He had his dark sides too—capable of rageful outbursts and insensitivity toward those he loved most. He could be arrogant and a show-off. His father had hit him when he was young, and he refused to confront it. He hadn't been honest about the chronic disease he was living with. He was competitive and occasionally vindictive. Verbose with the facts he knew, he could command the floor for too long, boring others.

I found his flaws as magnetic as his gifts. Flaws made him interesting. More real. And while they were challenges to overcome, it seemed certain that someone so capable could wrestle down a few shortcomings. It was easy to forget that some shortcomings could be worse than

others. And that on TV they could always be maneuvered into usefulness, whereas in real life they weren't as easily containable.

The episode we watched that first night—*Manchester, Part One*—bears some classic *West Wing* imprints. Parallel storylines in two time frames. In the earlier one, it's raining in Washington the night the president announces he will run for reelection. In the later time frame, it's four weeks later and clear skies while everyone is either on Air Force One or at the president's home in bucolic New Hampshire preparing for his official reelection kickoff. The cuts back and forth are frequent, doling out the story in small increments that eventually amass into a coherent whole.

The plotlines are dense, churning up the action and preventing anyone, viewers included, from much reflection. There is a coup in Haiti that threatens the American embassy, the aftermath of the president's announcement that he has concealed his diagnosis of multiple sclerosis, arguments about the president's New Hampshire speech, the First Lady's wrath at her husband for breaking a promise, tobacco legislation, approval of RU-486, potentially career-altering talks while playing pool, and a lot of bickering that masks the staff's resentment at the president for withholding the fact of his illness.

I couldn't keep it all straight. I was unaccustomed to the fragmented shaping, and I didn't know the entire two-season history. I hadn't seen the season finale in the spring, which would have helped orient me. Sometimes I didn't even realize when the time frame had changed.

Thus, I was compelled at the commercials to reveal my ignorance by asking clarifying questions. The man in the blue shirt—Tom—always answered, guiding me along.

Some of what *The West Wing* taught me made so much sense that as soon as I heard it I felt like I'd always known it. What the acronyms POTUS and FLOTUS stand for. That one member of the Cabinet sits out the State of the Union address, just in case an extraordinary event wipes out the entire House chamber. That the United States Marine Corps band practices four hours a day. That if the president needs to meet with someone but his only available time is while he's traveling, the person joins the trip, and the meeting takes place on Air Force One.

Other facts were more obscure. Andrew Jackson brought a massive block of cheese weighing more than a ton to the White House and invited the public to come in and consume it while discussing issues of the day. When a president is reelected, cabinet members traditionally submit letters of resignation that the president can either refuse or accept. Abraham Lincoln signed a pardon for a union deserter the day he was assassinated. AA meetings can happen anywhere, even in the basement of the West Wing. Each fact beckoned me further inside the world of the Oval Office. I wasn't sure if all the tidbits and stories about working there were true, but the mystique they created was enough. I was seeing inside some version of the Oval Office, and I was hooked.

Before *Manchester, Part One*, I didn't know Aaron Sorkin's other work—or more accurately, I didn't know I already knew it. After Tom and I began dating, I learned more about Sorkin's oeuvre. There was *Sports Night*, which was off the air, but I had heard about it in the ways we learned about such things then—word of mouth, newspapers, magazines, and the Television Without Pity website. In those days, shows were impossible to see if they weren't released on video or DVD. *Sports Night* hadn't been. Eventually, I ordered a set of homemade CDs on eBay as a present for Tom. Though the quality wasn't very good, we watched them all.

I had seen *A Few Good Men* but watched it again with new knowledge of its screenwriter/playwright. I had never seen *The American President,* but we watched that too, uncovering several story threads that were later stitched into *The West Wing*. From then on, we settled in to watch it again whenever we found it on TV on a lazy weekend afternoon.

Though aspects of Sorkin's signature style have been parodied, underneath the hallmarks of his writing runs a taut thread. He favors stories of a man's conviction in fighting for what he believes in. In 2002, Tom and I were both ready to be inspired. We were matched in our eagerness to see that some good could be salvaged from the mess our country was in, from the audacious malevolence that made nineteen men take command of four jetliners that bright Tuesday morning, and from the way that our jobs toppled along with the towers, right at the time we had both hoped to be soaring.

———— WW ————

The West Wing used music with strokes of virtuosity I was not used to seeing on network television dramas—and it did so using songs I knew. Dire Straits, the Boomtown Rats, Bob Dylan, even a tune from Gilbert and Sullivan's *HMS Pinafore*. Recognizing the music made me feel the creators were sending out a message, and I was getting it.

Sometimes, a specific song acted as a dramatic map to the episode, informing story arcs and mood. An episode from Season Two, *Somebody's Going to Emergency, Somebody's Going to Jail*, takes its title as well as its themes from the lyrics of a Don Henley song. It opens with Henley singing about how change can arrive as fast as a New York minute while Sam, Deputy Communications Director, wakes on an office couch where he has been sleeping each night since learning his father has been having a twenty-eight-year affair. Throughout the episode, Sam ignores his father's calls while he helps a woman seeking a pardon for her grandfather who died in jail for perjury related to treason. Sam discovers the man was a spy and, enraged to an inappropriate level, decides to tell the woman the unvarnished truth about her grandfather's betrayal. He's on the verge of ripping away her illusion when he realizes the anger he's been holding at bay has less to do with the spy and more to do with his father's infidelity. As the episode closes, Henley sings the title lyrics again and reminds us to hold tight to love because troubles are always lurking.

Everything that's in the lyrics is embedded in the episode. In the two major storylines, somebody's in some kind of jail or purgatory and somebody's in crisis. Danger is at the threshold, pushing the characters to the edge of a moment when everything is about to change. The lyrics shape the story, but the connections aren't exaggerated or pedantic. They aren't even necessary to enjoy the show, but they add layers of structural integrity

that make for deeply satisfying viewing. They also reveal that the creators of the show had the souls of true artists, who took care to add small touches that not every viewer would notice, upholding their own pride in their craft. I loved that I'd met my husband while watching a show like *The West Wing*—it matched our creative spirits, our respect for well-told stories. It showed we had good taste.

After Tom and I moved in together, I developed an interpretive dance to the show's musical theme played during the opening credits. As the orchestra began, I would rise slowly from my seat, arms arcing like a ballerina's, and step and twirl across the room, swooping my arms up and down in time with the violins, crouching low and then spinning upward as the music ran up the scale, then sinking back down to the floor for the quiet end. Every single time, Tom laughed, so I kept doing it.

More than anything else, *The West Wing* was about relationships. And it's not surprising, on a show about an office, that a lot of air time is devoted to the relationships between principal staffers and their office assistants. These pairings form close bonds—so close that each one takes on familiar aspects of coupledom. The president and Mrs. Landingham bicker about each other's foibles. The president and Charlie rib each other good-naturedly to hide their affection. Leo always gets the message when Margaret telegraphs indignation, and in turn he tolerates her occasional conspiracy theory. For Toby and Sam,

Ginger and Bonnie remain largely in the background of their bullpen, coolly efficient and mostly unflappable. CJ has a cheerful, protective shadow in Carol. These are office marriages, committed and faithful to the end.

There's a purity to these couples that I love, but there's something unsettling in them too. One person is always in the driver's seat, always the boss who ultimately calls the shots. The other person takes a supportive, backup role. Was that the reason these relationships worked so well? They certainly weren't as turbulent as the only marriage portrayed on the show: the president's. If I was looking to the show for models—not that I was, at least consciously—so many of the relationships were strong, but the supportive roles were almost exclusively held by women. Even the first lady—especially the first lady—needed to step back and stand by, or behind, her man on occasion. What did it mean that sometimes the lines between assistants and wives crossed? What did it mean for my future as a wife?

For our wedding, I created a map of our friends, almost as complex as the family trees I also made, to explain how everyone knew each other. It all led back to the night we met. To our great amusement, the map prompted our friends to argue about which of them was the linchpin in the mechanism that had brought us together that first evening we watched the show.

Tom and I delayed our honeymoon for a couple of years, but when we finally did go, we traveled light. Still, we carried a laptop so that on the ten-hour flight to Greece we could watch *The West Wing*. We watched with two sets

of headphones, leaning in toward each other to see the screen, and didn't stop until the computer's battery was fully drained.

Once in Greece we largely abandoned the computer. On the first night of our trip, at dinner in a seaside restaurant, the conversation turned to some of the weak spots in our two-year-old marriage. We spoke from our respective corners, and I regretted that we weren't having the romantic dinner I wanted. We drank wine and talked some more, and slowly the problems we'd laid out on the table looked like they'd been delivered to us along with the fresh sardines and horiatiki, and could be carried off with the dirty plates. The next day dawned sunny and breezy, and we stayed on the edges of the island we were on, not venturing toward the interior.

———— WW ————

A love match needs romance to survive, but sharing the actual work of life benefits from efficiency. And it is only on television that efficiency comes across as foreplay. On *The West Wing,* no other couple demonstrates this better than the Deputy Chief of Staff and his assistant. Josh and Donna joke and flirt around the edges of their copious amounts of work. They track each other's love lives and take turns crushing on each other, foiled by timing and circumstances that never align. Through it all their banter flares bright, operating on multiple levels, like most of Sorkin's dialogue—but these two have a chemistry that moves the dialogue from snappily quippy to memorably devoted. It's a perfect Sorkin romance.

Early in Season Two we learn the origin story of how Donna came to be Josh's assistant. It's classic Donna can-

do. She simply shows up in Bartlet's campaign office and puts herself to work, assuming the role of Josh's assistant. When he discovers it, he tries to shake her off, but relents when she says, in a massive understatement, "I think I can be good at this. I think you might find me valuable." All Josh does is look at her, a little piece of him falling for her right then. Because it's true: Donna has already proved her worth again and again, as an assistant but also as a citizen, a friend, and a woman.

What works so well is the waiting, the back and forth, the long courtship. Sorkin has said that the decision to keep Josh and Donna in a romantic holding pattern was strongly advocated by co-producer Thomas Schlamme, who was certain that deferring would be better for the show. It's true, and not just because it kept the storyline in suspense. Only through several seasons does it become evident that Josh and Donna's work relationship is closer, more reliable, and longer-lasting than either of them can manage in their personal lives. Postponing the inevitable complications served them well over the long haul. Some things you only learn with time.

———— WW ————

At some point, Tom and I bought DVDs of Seasons One and Two. Even when the show was still running those first two seasons felt different, edged in gold, perfectly preserving an era. After we had moved to Boston, some close friends came over one rainy day. In the living room of the house we had bought, the four of us and our dogs spent the rest of the afternoon eating popcorn and watching and reveling in the glory days of the Bartlet administration. After one particularly stirring

speech delivered by the president, my friend and I looked over at our husbands and realized they were both wiping their eyes. We teased them but were proud of our sensitive, hopeful men for wanting to believe in a president, in something good that also could be real. I don't know if the tears came from inspiration or regret, since it seemed clear by then that we wouldn't be going back to a more innocent time.

Tom and I were both capable of retreating into our work. We fell into habits, as every couple does. Stories and jokes became familiar, as did irritations and arguments. We each had the same hopes we'd always had but they were tacked onto each other now, and some of them were fraying at the edges.

By the time *The West Wing* ended we were living in New York again. We had moved quickly, sold our house at a loss, chasing jobs and ambitions as the economy began to tank once again. I don't remember those last few seasons very well. Some characters had left and others were new. The passion and urgency of the early years was diluted. I still watched the show, but not religiously. Tom traveled a lot for his work, and sometimes I watched without him. He didn't seem to mind missing it and only watched an episode later if I turned it on. I took care to watch the final season, especially for the satisfaction of watching Josh and Donna finally get together. I don't remember it clearly, but I'm certain Tom and I saw the series finale together, making an event of it and savoring what we could, then proclaiming those first two seasons superior. The peak.

I didn't know until well after *The West Wing* was over that the missing ingredient during those last three seasons was Sorkin. I'd rightly sensed something had changed—he had left the show. Had Tom known? Had he told me? Sometimes I forgot things he told me. Sometimes he didn't listen to me, either. The show went on but there was a hole at its center with Sorkin gone. What would it have been, and how long would it have lasted, if he had stayed?

The series ended right as the United States ramped up for a historic election. Less than two years later Tom and I went to DC for Barack Obama's inauguration. We put on layers of warm-weather gear, wedged ourselves into the Metro toward downtown, and stood in the shadow of the Washington Monument to watch the historic inaugural address. We didn't return to the National Mall for two years, when we attended the massive pre-election rally hosted by Jon Stewart and Stephen Colbert in front of the Capitol. A few weeks after that, in the New York City apartment where we lived together, three and a half years after *The West Wing* had ended and a week after the midterm elections, we decided to separate. He was the one who moved out while we figured out what would happen next. When he left he packed clothes, his computer, and the DVDs of Seasons One and Two.

For most of *The West Wing,* no staffer can catch a break when it comes to romantic relationships. They are attracted

to partners who are unsuitable or their unions are tied up in tragedy they can't shake, infusing the breakups with inevitability. Leo's divorce comes early in Season One, after he tells his wife his job is more important than his marriage. Donna hits it off with a man who turns out to be the Republican counsel for a group out to skewer Bartlet; she dates someone else who, in the course of following a covert order from the White House, gets into hot water with the Department of Defense and is transferred to Italy. Charlie's romance with the president's daughter cools after an assassination attempt or because he works too hard, or both. When Josh and Amy take opposite sides in a political fight, Amy loses her job and Josh loses Amy. Sam's first romantic interest on the show turns out to be a professional escort. He turns to his boss's daughter, and though they flirt heavily, they never seem to manage a proper date. Even Toby, the only one of the team to reach the point of proposing marriage, is refused—by his ex-wife, who makes it abundantly clear she won't marry him again.

And then there's CJ and Simon Donovan, the Secret Service agent assigned to protect her after she receives death threats. In the moments after the stalker is apprehended, the romance is on. Later that same night, Simon happens onto a convenience store robbery and the match ends in a hail of bullets and a montage set to Jeff Buckley singing "Hallelujah."

Tom and I both knew that song when we met—he loved Buckley's version, while I was partial to Leonard Cohen's—and we asked a friend to play it at our wedding. Later we reconsidered its melancholy lyrics and moved the song to the rehearsal dinner. Maybe we shouldn't have let it anywhere near the festivities. It didn't seem so

dark to us—or we felt stronger than its darkness—but in retrospect, of course, our choice. To our union, each of us brought our dreams, the values we'd been raised with, our expectations, some stubborn ways.

And we brought the shadows within us that kept us from reaching out to each other instead of folding up and in. We didn't have the excuse of White House jobs that sapped every second of our days, or created intractable disagreements that struck at the core of our personal connection, or that literally put us in the line of fire. Making it work does not make for dramatic television. Who knows, maybe that was a part of the problem all along.

The first person I dated after I was single again was another writer. I knew he liked *30 Rock*, and when I saw the episode that features a cameo by Aaron Sorkin I sent the man a link to the scene. We'd never discussed Sorkin, but I felt sure that even if he didn't know who Sorkin was he'd still find it funny. But this new man responded that I'd sent him two of his favorite things, together. He seemed impressed. In the end, the exchange felt strange to me. It wasn't that it felt like betrayal. Just far away from where I'd been. The whole thing—even the cameo itself, where Sorkin makes fun of himself—possessed a faint ersatz sheen, a whiff of the reprocessed. I'd loved Sorkin's work first with someone else.

On the tenth anniversary of 9/11, it seemed to me that the two dates bookended my life with the man I'd married—a decade that suddenly felt squandered. In divorce, I didn't recognize myself. But, as I'd said to Tom

a few months before we separated, I hadn't recognized myself for some time. I seemed to have missed my New York minute, the moment everything changed. Now recognizability feels like something for other people. Who I am is not who I used to be. I live in a suburb near Washington, DC, back after being gone for twenty years. I'm not young anymore, and I'm married to another man. I've lived a few lives and the ones behind me are no longer inhabitable.

I don't avoid watching *The West Wing* because it makes me think about my first husband. I still love watching the show. And when I do watch, I mostly think about what it means to tell a good story. What's different now, though, is that as the team onscreen answers their beepers and does their walk-and-talks through the hallways of the Oval Office, I feel the presence of some younger ghost of myself hovering nearby. *The West Wing* left its imprint on her—me. There's no denying that I've never been the same since *Manchester, Part One*.

———— WW ————

THE WEST WING CHANGED OUR FAMILIES

In a family of seven very different people, *The West Wing* is the one thing we all have in common. We've all watched and rewatched it, can quote it, discuss it, and enjoy it.

Colleen Harris, 37, Seattle, WA, digital marketing

The West Wing was the first—and so far the only—show I watched from start to finish, almost all the episodes, as they were broadcast. Friends shared the experience with me, and the show and its characters and memorable moments became part of our vocabulary and shared memories.

As my three daughters grew up, the show became available on Netflix, and by the time the two older ones were in high school I introduced it to them. I was amazed at how well the writing and characters held up, and they watched the whole thing. It's now part of our family vocabulary and stories.

My older daughter claims that she got a Five on the AP Government exam because of *The West Wing* (her teacher was lackluster), and my middle daughter is now a political science/math major, planning a career in politics on the progressive side. She was working on a local campaign in her college town last fall and texted me a photo from the campaign office, where they were watching episodes

of *The West Wing* while phone-banking. I recognized the scene immediately: it was the one where CJ is on a treadmill in the gym, trying to be all casual while she chats up a guy, and then she falls off. When my daughter told her campaign manager that I knew the scene right off the bat, he replied, "I have to meet your mom!"

Intergenerational, great writing, and progressive speechmaking that helped me endure the dark years of George W. Bush. Thank you, *West Wing*!

Michele Thomas, 54, Lebanon, Indiana, publishing

———— WW ————

During a long weekend in the summer of 2009, my family and I headed to our little cottage to relax and fight about how high to turn up the window-mounted air conditioner. We never had a TV there during my childhood, but in my late teens someone brought up a small set with a DVD player so we could watch a movie inside at night after the mosquitos appeared. I brought Season One of *The West Wing* with me and suggested we watch the first episode. I honestly have no idea why I did that. I think the last show we had watched as a family was "Home Improvement", and it seems hard to believe Tim Allen's grunts could be replaced by Martin Sheen's thoughtful policy discussions, but it worked for us.

We watched an episode every night we were at the cottage, and we kept our new tradition intact when we returned home. My sister and I would sit on the couch with our mother next to us in the recliner while my father would make a little bed out of blankets and pillows on the floor and curl up with the dog. We would typically view two episodes back to back, but sometimes we would

push it to three if I knew there was a really good one coming next. We didn't watch it every single night, but often enough that it became a regular part of our lives.

My father and I often had little arguments over the political actions of President Bartlet and his team. I would argue from the perspective of happy liberalism that comes from being twenty years old and not having the world screw you over multiple times just yet, with my father espousing the grouchy conservatism that seems to find all us all after we hit fifty and start thinking about our dwindling retirement plans. We never had a shouting match or anything like that. We were both fairly stubborn and set in our ways, but we still knew a good story when we saw one.

It took the four of us about a year to finish watching *The West Wing*, and we were so enamoured with the revolving threads of American history woven through the show that the following summer my father and I took a trip south to Washington D.C. by way of Gettysburg. He was the fan of the movie in which Martin Sheen portrayed Robert E. Lee and had spent a lifetime watching every Western film that dealt with the aftermath of the Civil War. We took a bus tour around the battle field—the kind that has speakers set up to blast the sounds of galloping horses and rifles going past your head. I could just imagine President Bartlet loving the tour, while Josh would twitch with every unexpected blast.

After our battlefield tour finished, we traveled to Washington to explore the more recent period of American history, the one that featured Martin Sheen. We spent two days walking around the city, past the reflecting pool where Leo strong-armed a senator, the Capitol Building where Josh had a freak out, and in front of the Lincoln Memorial where the President once arrived, oddly free of Secret Service accompaniment, to contemplate his next

move. We went to the National Archives and saw the real constitution that the fictional President Bartlet fights to protect. We even stood in front of the White House and saw the real West Wing. There was a conspicuous lack of young staffers simultaneously walking and talking, but it was still a great experience. The two of us talked about everything we had seen while on the drive home, including the hours it took just to get off the George Washington Parkway.

It's been almost four years since we took that trip and over a year since my father died. My relationship with *The West Wing* is a little different now. I'm grateful that we watched it because it made us look past our political differences and be inspired by the fact that good people can work together for the betterment of all—even when they disagree—because eventually we'll all fall in a hole. The greatest amount of time my parents, sister, and I were together as adults was when we were watching *The West Wing.*

Matt Dodge, 26, Toronto, Ontario, copywriter

THE WEST WING CHANGED HOW WE DEAL WITH DIFFICULT TIMES

I am an educator and deal regularly with troubled college students. After the Rosslyn shooting, Leo tells the story of the guy who falls into a hole and of who could and would really help him—someone who remembered that he'd been down there too. That story has been very useful.

Jill Kelly, Santa Rosa, California, Instructor in
Philosophy, Humanities, and Religion

———— WW ————

When I first became ill and was adjusting to a new life with continual pain, I began having frequent panic attacks and couldn't sleep at night. I would lie in bed, completely overwhelmed by my current circumstances, and I would watch *The West Wing*. There was something so calming about the drab colors of the set and costumes, something soothing about the cadence of perpetual dialogue, and something comforting in the relationships of these beautifully human characters. I watched the first four seasons over the course of several months. I railed against God with Bartlet in *Two Cathedrals* and continue to draw comfort from the words Leo told Josh in the lobby at the end of *Noël*. This show is so much more than a show to me. It gave me stability when I had none; I knew

that I would see the same people in the same building each time I began an episode. But more importantly, even, than stability, this show gave me hope. No matter what happened over the course of an episode or story arc, there was always an undercurrent of resilience. Nothing encapsulates that idea more than two simple words, "What's next?" And those two words helped me gain my life back. When setbacks or emergencies or difficulty came, dusting myself off and asking, "What's next?" did more for me than any other mantra or positive thinking. It allowed me to acknowledge past circumstances in a way that didn't hinder my ability to look toward the future. This show taught me innumerable lessons, but this is the one I hold most dear.

Elizabeth Barclay, 22, Kansas City, Missouri

———— \/\/\/ ————

I was diagnosed with multiple sclerosis in 2003. I had no interest in watching a show about the inner workings of the White House, and everyone kept telling me about President Bartlet's diagnosis—so I refused to watch the show for the same reasons hypochondriacs shouldn't watch *House*. Even so, the mere thought of a guy running the country, having the same condition as me (and way more stress), made me feel weirdly better. About ten months later, I broke down and watched it. Now it is one of the bits of advice I pass on to others who tell me they have been recently diagnosed. Watch this—you'll feel better.

Cat Smith, 44, Brooklyn, NY, actor

FALLING IN A HOLE:
HOW **NOËL** HELPED ME BACK OUT
by Jennifer Allen

Fiction teaches us that when a terrible thing happens, there's some kind of ominous warning that precedes it. Whether it's sinister music, someone making a suspicious comment, or simply the fact that we're coming to the end of a series or chapter, you know it's coming. Life doesn't work like that, and you never quite realise how much so until something breaks your brain.

I went to bed one night as a young adult in a new job and reasonably content with my life. Within a few hours, it all changed.

I was woken around five a.m., by my mother, to help my father who had fallen out of bed and couldn't get up. He'd had a virus in recent weeks, but doctors weren't concerned; he'd be fine. Briefly confused by what was happening, within seconds he started fitting. I soon felt powerless while my mother performed CPR on him, and an emergency operator on the other side of the phone kept telling me the ambulance would be there soon. It showed up, but it didn't really matter in the end. Nothing could have helped him, and it was utterly terrifying. Death was nothing like what TV had taught me it would be like, so much more violent than simply 'slipping away'.

I went numb, and the fear lingered for an exceptionally long time. Everything terrified me, but not in an overt

way. I tried to keep busy. Desperately tried not to think. Nights, though? They were the worst.

One night, I stayed awake until dawn. Every time I'd shut my eyes, I'd think I could hear my mother crying out for me again, or I'd see it happen all over again. I wasn't remembering the event; I was reliving it. I couldn't sleep. If I slept, it might happen again. After all, it happened that one time. Why not again? Aside from a fitful, exhaustion-induced hour or two, I didn't sleep. Then the day would begin again, and I'd keep busy. The slightest noise would immediately put me on edge. I constantly had a bitter taste in my mouth and felt like I was waiting for the world to cave in. I had no interest in living. I wasn't suicidal. I just wanted it all to stop. For my pain to end.

I couldn't talk about it to people because it made no sense to me. Other people suffered loss, and they seemed okay. I thought I must have been just being a wimp. I didn't want to explain. It'd sound like I was getting overly dramatic or whiney. Instead, I got angry, distant, and scared. I was lonely but had no idea how to reach out to anyone. I saw a doctor, but either because I wasn't blunt enough or because he didn't really care, nothing much came of it, other than a lingering feeling that I was blowing things out of proportion.

Instead, I found an unlikely ally in a TV show I'd seen years previously. I remembered watching the first couple of series of *The West Wing* when it first aired in the UK. It had hooked me almost immediately. I'd been saddened but gripped when my favourite character, Josh Lyman, was nearly killed at the end of the first season. That sadness had grown in the second season when he'd dealt with mental health issues because of the shooting that nearly ended his life. I'd stopped watching at some

point and didn't really think any more of it until this point in my life.

I'd got to the stage in my grief where I could cope but little really enthused me. I decided to pursue a "new" TV show to keep me occupied in the evenings. I went for *The West Wing* because it was cheap on Amazon, I had gift vouchers, and I'd seen *The Cabin in the Woods* recently and it reminded me of how much I used to love 'that guy out of *The West Wing*'.

The show clicked with me again, as I'd always been a fan of politics and of fast talking. It started giving me something to look forward to each evening. A safe place to return to each night, which provided some kind of stability. More importantly, Josh's struggle with PTSD made perfect sense to me.

When I watched *Noël* for the first time since my father's death, it was as if Stanley, the therapist, was speaking to me. He explained the difference between remembering a traumatic event and reliving it, and I realised I was still doing the latter. There's a moment where he tells Josh, "You're in nine kinds of pain. You don't know what's going on inside of you, and you are so locked into damage control". It resonated with me. I'd spent a long time desperately trying to keep it all together, hoping that if I just got on with things, my brain would click back into place. I didn't know what was going on inside me, other than that my brain felt broken, and I had no idea what to do. I saw the flashback of Josh putting his hand through the window to stop the pain, and it made so much sense to me. I didn't do the same thing, but I could understand why someone in his position would be so frustrated and desperate to stop the memories looping round and round his head incessantly. Josh never says if he's suicidal, and I

think I know why. He doesn't want to die; he just wants to be who he was before, and he's angry and upset and scared. Just like I was.

Everything terrifies him, and he knows life is so easily thrown off balance by things out of his control. He's also afraid because he thinks if he tells people, they'll think he's crazy, and his life will be ruined. Paranoia kicks in again and again—that desperate urge to cling onto what little normality you've got, even if you hate who you've become.

I started seeing parallels. One time, when under a lot of stress at work, I was struggling to get my boss to understand me on an issue, and I turned aggressive. Fortunately for me, it was done remotely via Skype, but I was still terrified afterwards of losing my job. It was the only thing I had real control over at the time, and the only way I could feel "normal" and significant again. Luckily, my supervisor understood this and had a chat with me privately about things and coping. I'd never have opened up to him otherwise, fearing that admitting a mental problem would be seen as weakness and that I'd be replaced by someone more stable. Instead, he offered me advice and a listening ear. He was, effectively, my Leo in that situation, but I didn't really think it through until seeing it on screen.

I researched PTSD, but most of what I found referred to combat-related PTSD, and I couldn't relate to it. It also made me anxious that maybe I was just being overly dramatic, even though I knew I matched so many symptoms from other forms of research. All the cases also seemed to be people still struggling. I needed inspiration. Someone who had come out the other end, a little broken maybe, but still a decent and happy person. So, despite

his being fictional, I decided that my inspiration would be Josh. Sure, his progress was dictated by a writer, but it seemed realistic and insightful to assume that someone somewhere was in a position of authority while struggling with mental health problems

I threw myself back into life. I figured no matter how stressful my job was, it wasn't being Deputy Chief of Staff to the President and therefore couldn't be that hard to do. I started saying yes to more work and reminding myself of two important quotes from *The West Wing*. One is from Mrs. Landingham to a weakened and grief-stricken President Bartlet: "You know, if you don't want to run again, I respect that. But if you don't run because you think it's gonna be too hard or you think you're gonna lose, well, God, Jed, I don't even want to know you." The other is Stanley's proclamation to Josh that he wouldn't constantly be afraid of music "because we get better". Both helped me get over the fear. They reminded me that, yes, things can work out in the end. Such advice was how I ended up taking phone interviews with important people, despite the fact that I'd always backed out of such things in the past. It was also how, despite a fear of the sea, I ended up rowing in a boat in the middle of the sea with a group of experienced rowers whom I'd only known for thirty minutes.

I'm not cured. I never will be. Adrenaline, whether the good or bad kind, made me want to run away, and I learnt that the more I worked through it, the better things went. I have the tools to be in control. Seeing ambulances and hearing their sirens unsettles me for a moment, but I take deep breaths. I've been woken up by my chronically ill mother being violently sick, and it reminded me a little too much of *that* night, unsettling me

for a few days afterwards, but knowledge is power. I knew I'd be ok. Inner confidence can count for a lot. And guess what? Standing with your back to a wall while taking deep breaths and thinking things through really does help. Just don't stand behind a door. It will hurt.

As crazy as it sounds, the main driving force was the realisation that others had been down that hole before, but knew the way out. Even if they were fictional, they could help me too. Josh Lyman reminded me that you can have something terrible happen to you but that it doesn't have to define your character. You can work through things and come out a better, if different, person from who you were before. I don't know what my mental health issues would be classified as, but whatever they are, I see it as a little devil on my shoulder. Sometimes, it tries to overwhelm me with lies, paranoia, or simple fear or anger. Other times, it can be asleep for a long time. Either way, it won't rule over me anymore. I might falter for a brief time, but I'll pick myself up and dust myself off.

I now find that each time I come back to *Noël*, I find myself a little more comfortable. It's still as stressful to watch as it was the first time round, but it's not one that reminds me of how my life is. It's one that makes me feel empowered because one day I'm going to be just as in control of it all as Josh is by the end of the seventh season. Happy, in a job he's richly earned, and with someone to love. Nobody should need to be defined by their mental health issues or left to feel inadequate at not having dealt with something "perfectly".

THE WEST WING CHANGED OUR PHILANTHROPY

After the episode *Guns, Not Butter*, I became interested in Heifer International, and from that, Kiva Microlending and DonorsChoose. I met an online community of passionate people all trying to make the world a better place. They reminded me of my *West Wing* heroes. I've made 1647 microloans and supported 240 struggling classrooms. I also learned about issues and began to follow politics closely. In my small way, I have been trying to make a difference in the lives of others for over ten years now. *The West Wing* was the start.

Cheryl Sebrell, 61, Littleton,
North Carolina, retired teacher

Claire Handscombe

THE WEST WING CHANGED HOW WE DO OUR JOBS

The West Wing stopped me being ashamed of my idealism. I first came across the show as a young high school teacher. I had long been interested in politics and the differences between the American system and ours, here in Australia. I dreamed of a world where people with power wanted to do the right thing—even if it wasn't possible and especially when it was extremely difficult. I was (and still am) fascinated by how the characters combined their power with their humanity, and this is something I aim to always bring to my own work as a leader in Education.

I was inspired by the female characters—CJ especially—and also by the men and the refreshing equality between them.

On a lighter note, I frequently practice the "walk and talk"—as I'm sure many people do!—when things get super busy at work. The older staff love it, and the younger ones look bewildered... so I tell them about the show and offer up my collection. Whenever someone borrows it to watch for the first time, I feel a touch of envy.

Cathryn Stephens, 35, Melbourne, Australia, teacher

Claire Handscombe

I watch the entire series, while sitting up nights waiting for my mares to foal on the horse farm that I manage, and have been doing so for years.

<div align="right">

Reddy Hannum, 59, Pennsylvania,
horse breeding farm manager

</div>

THE WEST WING CHANGED OUR CAREER CHOICES

The Mrs. Landingham episode really changed my life.

I have always been a fairly positive, forward-thinking guy, but I'd become complacent. I watched *Two Cathedrals* while I was trying to make a decision about a job. I was in an unhappy relationship at the time and on the cusp of making what would've been the wrong choice: not accepting the position I was being offered.

For the first time, I realised how fleeting and precious life is. The way Martin Sheen, as President Bartlet, grieved for the loss was totally palpable to me. When Leo told President Bartlet about Mrs. Landingham's accident that was a defining moment in my life.

That single, one-hour episode of a TV programme filmed years before, thousands of miles from my home, opened my eyes.

I took the job, met my new girlfriend through it, and am happier than I've ever been.

<div align="right">Simon McNally, 29, United Kingdom</div>

I was fiteen years old when *The West Wing* first aired, and my family (already hooked on Aaron Sorkin's writing from *The American President* and *Sports Night*) watched from that first Wednesday. Not only did the show expand my world view, it captured my attention with its passion, eloquence, and humor. Without my realizing, it began

to change my interests from what was going on in the cosmos to what was going on right here on Earth. *The West Wing* filled me with the same wonder and awe that I'd had about the starry night sky. I had decided when I was eight years old that I wanted to be an astrophysicist and an astronaut. By the time I graduated from high school, I had changed my mind from astrophysics to American government. I'm now an attorney with a specialization in social justice.

Even now, more than ten years after *The West Wing's* final episode, I watch it whenever I'm feeling sad, sick, or just depressed about the state of the world. Its optimistic view of the past and the future never fails to rub off because "every time we think we have measured our capacity to meet a challenge, we look up, and we're reminded that that capacity may well be limitless."

Jessica Seargeant, 32, Seattle, Washington,
Nonprofit Consultant

———————— WW ————————

The West Wing was what got me into political things. As a result of that, I joined my High School debate team and that made me care about school in a way that I hadn't really before. I made a number of good friends that way, and it shaped what I ultimately wanted to do, at least at the time, for a career. I wanted to work in politics or possibly as a lawyer. I wanted to be Josh Lyman when I grew up. It made the work of politics look like such a noble calling and something that would be fun as well, in a way that used the skills I had. So that's really why I went to George Washington, which is in DC, and why my major was Political Communication, which at GW is basically political operative boot camp.

It's actually a lot more fun as an academic discipline than as something I would want to do as a career, so I'm in law school now. But I'm extremely glad that it worked out the way that it did because I don't think, without that initial kick to start caring about school—being inspired about school—I would necessarily be where I am today.

Tom Lawrence

Claire Handscombe

THE WEST WING CHANGED HOW WE SPEAK AND WRITE

You quote it all the time. You'll say something to your friend and you don't even realise it's a quote from the show, and then you'll go back and rewatch it, and you'll be, like—oh, that thing I say once a week, that's actually something Josh said to Toby once.

Josh Shpayher, 34, Chicago, lawyer

I did watch it back-to-back writing a novel—a thriller. Particularly because I'd got some American characters, and I wanted a certain kind of bounce to them. So it's affected my writing because I'm relatively weak on dialogue, I think, and the dialogue now in the book is pretty good. It has occasional moments where it sort of flies.

John Pollock, 52, UK, writer

We are two speechwriters, from two countries, with one story.

One of us, Rune Kier, worked with diversity and communications in the Danish capital, Copenhagen. Through *The West Wing*, he came to see political

speechwriting as his means to create social change. The inside-look at government made him believe in delivering powerful political ideas with effect beyond the podium. Meanwhile, in Holland, the other, Jan Sonneveld, had worked in government communications for years until *The West Wing* reignited his passion for government as "a Powerful Force for Good."

Growing piles of research suggest that storytelling works regardless of whether it reflects reality. It's how our brains are wired. When we receive pure information, our brain activates the limited parts designed for processing numbers and language. Listening to stories, however, activates the very same neurons as experiencing the story ourselves: in our brains, we become the protagonists. That is why stories have such an enormous impact on our lives, whether we realize it or not. Even fictitious, they are only inches away from lived reality.

In South Africa, one episode of the television series, *Soul City*, had a whole village rise up to protest domestic abuse and collectively stand by battered women. Afterwards, real villages followed the example of their fictional role models. It broke the silent acceptance of domestic violence by showing that another reaction was possible and desirable. The same happened on issues like prejudice towards AIDS and abuse of alcohol.

The West Wing inched in on us and shaped our reality, guiding us towards political speechwriting. We took the power of storytelling to heart. Danish and Dutch politics are commonly seen as dirty, cynical business. Politicians might start their careers with lofty aspirations, but in the fog of daily politicking those dreams easily become invisible to the public eye. In *The West Wing*, Toby Ziegler and Sam Seaborn fight as speechwriters to preserve government's

big ideals. Our central task is to cut through the noise to communicate a vision that connects the speaker with the audience. For us, storytelling is the ideal way to do it.

Inspired by *The West Wing* and its influence in our own lives, we use storytelling and cultivate our idealism to fight ever-lingering cynicism. It enabled Sonneveld to help a close friend and local politician to shape his ideas and put them into words for an inspiring TEDtalk.

The West Wing inspired Kier to weave together statistics from WHO and expert climate scenarios to write a speech called "Climate Change and the Story of Sarah"—an urgent call to the medical profession. The speech was published in *Vital Speeches International* and nominated for a 2014 Cicero Speechwriting Award.

The West Wing story might not perfectly reflect White House reality, but it affected our reality nonetheless.

Jan Sonneveld, 33, The Hague,
The Netherlands, speechwriter,

Rune Keir, 36, Copenhagen,
Denmark, speechwriter,

Claire Handscombe

THE WEST WING CHANGED HOW WE TEACH

I was a youngster in the early twenty-first century. *The West Wing* gave me hope for what I could achieve for others throughout my life. It inspired me to get involved in political advocacy throughout my schooling. Additionally, it motivated me to use my role as a high school teacher for rural Australian students to inspire the next generation of leaders and help them dedicate their lives to public service.

More humorously, when in need of a pump-up, I love re-watching President Bartlet's opener to the debate with Governor Ritchie. Always guaranteed to get me back in the zone!

Christopher Weinberg, 24, Melbourne, Australia, teacher

I became a teacher ten years ago. I wanted to raise the issue of homeless veterans. I really thought *In Excelsis Deo* was a great episode—the idea of Toby going to have a proper funeral for this veteran, who they were just going to sweep off the street like the dead carcass of an animal. And I think the kids really got it.

John Brady, 39, middle school U.S. History Teacher

(John shows *In Excelsis Deo* to his 8th grade US history class every year on Veterans' Day.)

——————— WW ———————

My three roommates and I joined Teach For America in 2009 and began our first year of teaching that August. The days were incredibly long and challenging. Every night after work, we would gather in front of the TV to watch one or two episodes of *The West Wing*. As I walked into school every morning at six a.m., I would often think about how excited I was to get home that evening and watch *The West Wing* with my roommates—we had only known each other for a short while, and the show certainly strengthened our relationship.

We enjoyed *The West Wing* for many reasons. It made us *love* our country so much more, and we are now hugely patriotic. (I'm wearing American flag socks as I type this right now). We were members of Teach For America, so every day we would go serve our country through education and then come home to watch others serve their country politically. We also worked a tireless amount— first-year teachers work nonstop. I vividly remember the episode when Josh takes coffee grounds out of the trash and reuses them; If he could work that hard for his country, then so could I! Our free time was two hours every night, from eight to ten o'clock, and that time was reserved for *The West Wing*.

One year, we had a snow day and decided to paint our dining room. We brainstormed what we should paint and naturally decided on an American flag. One wall is stars, the other wall stripes. We took the series' DVD box to the store and matched the color of the box to the navy that we painted the stars on—it's literally "*West Wing* Blue"!

The four of us, one doctor, one lawyer, one principal, and one teacher, are now spread out in three cities across the country. But we get together very frequently. I just returned yesterday from the lawyer's bachelor party, and

the principal said, "so I just finished watching *The West Wing* with my wife, and now I'm starting it back over for the third time!"

The West Wing inspired us as teachers and as Americans. The TV show and the painting of the room formed lifelong bonds that will never be broken. We live a *West Wing* lifestyle.

<div style="text-align: right">

Taylor Wells, 29, Durham, North Carolina,
middle school math teacher

</div>

Claire Handscombe

———— WW ————

THE WEST WING CHANGED HOW WE DO CHURCH

I stumbled across *The West Wing* by gracious accident, catching the pilot episode when it first aired. It immediately captured my imagination with Sam's love for great writing and Bartlet's stubborn optimism that America's better angels still have a fighting chance.

I'm a pastor who helped start a new church in the downtown section of Chapel Hill, North Carolina. We are an unlikely crew reaching college students, young professionals, and families. But about ten percent of our church family is made up of men and women who are experiencing homelessness. We are driven in all we do by the life and love of Jesus. Of course, He sets our course and leads the way, but it's strange how many times *The West Wing* has been an unexpected source of inspiration in our underdog story. It has repeatedly provided a spark of courage to take another step of faith in this journey. For instance, several of us passed on promising "John Hoynes" opportunities, guaranteeing stability and success. But we just couldn't shake the sense that we were supposed to trade in the certainty for the risk and adventure of building a long shot dream from the ground up. Even if others couldn't see it yet, we had "found the real thing in Nashua." And it has been worth the risk. The list of inspiration goes on—believing that a small group of committed friends could change the world, because it's the only thing that ever has. Finding my Leo, who is my best friend—smarter than me, the guy I would

trust with my life—and asking him to jump off this cliff. Remembering that words are music, and they have the power to inspire, transform, and "lift houses off the ground, whole houses clear off the ground." Caring about the outcast and forgotten, using the voice we've been given for those who are seldom heard. Always thinking about tomorrow, dreaming about the future, and asking, what's next? *The West Wing* tapped into a desire I've always had to be a part of the kind of story that matters. And even as I write this, I'm grateful again to be living a story like that today.

Matt LeRoy, Chapel Hill, North Carolina, pastor

THE WEST WING CHANGED
HOW WE SEE AMERICA

It's made me much more pro-America. It's made me recognise that there are very many decent, good, hard-working, impressive people in America.

John Pollock, 52, UK, writer

A VISION OF A BETTER AMERICA
by Katharine Van Riper

In many ways, it was a question of timing. When I first started watching *The West Wing*, I was seven months shy of my eighteenth birthday and just over a year away from the first election I would be eligible to vote in. If I had never seen an episode of *The West Wing*, I would have voted out of a sense of obligation, a sense of duty, rather than out of genuine interest or excitement. In AP Government, we talked about why so few young adults don't vote: they are busy, it's too difficult, they don't care, they don't believe it will really make a difference. For me, *The West Wing* isn't just about politics. For me, *The West Wing* is about hope.

I started watching *The West Wing* at the beginning of my senior year in high school. I was aware there were two parties, and it was so very easy to refer to them as sides—good versus bad or right versus wrong—but what I began to understand is that thinking that way is neither accurate nor helpful. And that brings me back to *The West Wing*. Quite possibly, my favorite scene in the whole of the series focuses not on the main characters, or even on a group of Democrats, but on a trio of Republicans: Ainsley Hayes and two of her colleagues. She has just returned from her visit to the White House, and they ask her whether she met anyone of value in the Democratic White House. Earlier in the episode she informed Leo McGarry that she found their administration "smug and patronizing and under the impression that those that disagreed with

them are less than they are and with colder hearts". What makes the final scene stand out is the fact that when asked about the worth of the administration, her response has been changed by her experience:

Say they're smug and superior. Say their approach to public policy makes you want to tear your hair out. Say they like high taxes and spending your money. Say they want to take your guns and open your borders. But don't call them worthless. At least, don't do it in front of me. The people that I have met have been extraordinarily qualified. Their intent is good. Their commitment is true. They are righteous, and they are patriots.[3]

Meeting the White House staff doesn't change her principles, nor should it. Politics isn't about having some magic bullet that makes everyone who disagrees with you suddenly change their mind. And that, I suppose, is what *The West Wing* really made me realize.

When Matt Santos addresses the public for the first time after Leo's death, he tells them that, "This race wasn't about [Leo] and it isn't about me. It's a vision for America that will outlast Leo and outlast me. There's an America that's bigger than any of us, and for those of you who have not voted, it's the only thing that should matter when you go to the polls tonight."[4] *The West Wing* is the representation of that vision, that bigger America: a better world, not a perfect one but a better one. It's not going to materialize or develop all on its own, but if we all get out there, if we get involved, if we talk to each other rather than at each other, if we work together then maybe we can make it a better world for everyone to live in. Politics so often seem to be a hopeless cycle of money and power,

3 'In This White House' (Season 2, episode 4)
4 'Election Day, Part II' (season 7, episode 17)

but maybe it doesn't have to be. *The West Wing* gave me hope and a reason to believe that maybe people aren't so terrible, and working together we could accomplish something great. And maybe CJ was right: "And if politics brings out the worst in people, maybe people bring out the best."[5]

5 'Stackhouse Filibuster' (Season 2, Episode 17)

THE WEST WING CHANGED OUR POLITICAL INVOLVEMENT

The West Wing convinced me that politics can be a force for good and a place that people can come together. I volunteered every free moment I could to try to elect a Labour government in the UK general election on 7th May 2015, and a huge part of that was because being a teenage fan of *The West Wing* convinced me that change only happens when people work for it. Decisions are made by those who show up.

Mark D Jackson, UK

———— VWV ————

When I was endorsed as the local candidate and began my campaign, I remembered Jed Bartlett shaking the first hand of the first member of the public. It was humbling when I experienced this myself.

John Thomas, 50, commercial food and beverage designer

———— VWV ————

It developed my way of thinking. Certain instances have really stuck with me, such as "tempting fate" and "when the man falls in the hole", especially during my

first real full-time campaign last year. Tempting fate had to do with the integrity of numbers—making sure that they are sound before jumping the gun on the result. And that helped out on the daily trail, as far as what doors we knocked, what numbers were called, how many people came to the door.

> Dario Scalco, 24, Louisiana, Legislative/
> Political Director with the Professional
> Fire Fighters of New Hampshire

"I definitely was never interested in politics until I watched the show. I was still in college, and I didn't follow the election of 2000. I remember hearing the results: Gore wins! No, Bush wins! No-one concedes. And I'm like, all right, whatever! You know, I didn't care. And then three years later I was working really hard as an intern on a political campaign. That was because of the show."

> Josh Shpayher, 34, Chicago, Lawyer

I started watching *The West Wing* two years ago because I loved watching Dulé Hill in Psych, and there were many *West Wing* references made on that show. I was hooked right away. I was so enthralled by the character dynamics and by the work that each character was doing. That work and the topics they covered really struck a chord with me, and it helped me realize that I wanted to pursue Political Science in college, and that is exactly what I did. Without

The West Wing, I may have never realized my love and affinity for the inner workings of a presidency and the dedication that goes into every decision.

Yoela Koplow, 20, New York City, student

I started watching *The West Wing* for the first time in August 2012, in my final year of high school. I was hooked almost instantly. At the time, I was applying to university. My intention all throughout high school was to go to university and get a Bachelor of Commerce and then go into the private sector. As I dove deeper and deeper into the series, I started to fall in love with politics, government, and serving for the greater good. By the time university applications were due, it was November, and I was halfway through the series. I still applied for a degree in Commerce, but alongside that I applied to a couple of universities for Political Science.

By the time acceptances started to come out in February, I had finished *The West Wing* and had just concluded my favorite course in high school—Canadian Politics. I was accepted to Queen's University for a degree in Political Studies, and I accepted it almost immediately.

While I understand that *The West Wing* is a glorified liberal television show that may overplay what it is like to actually be in government, it created a passion in me. I love the education I am currently getting, and I fully intend to enter the political world following graduation.

It is my dream to become the most knowledgeable person in the room during political campaigns, like Josh Lyman. To be the guy that the guy counts on, like him

too. It is my dream to write speeches that produce an emotion and are more than just sound bites, like Toby Zeigler and Sam Seaborn.

The West Wing jump-started a passion I had never felt before. It drives me to excel in school because there is that off-chance that if I work my ass off, I might get just a taste of what it is like to work in politics. I have made friends because of the show, and have gotten to know people better because of our common interest. I have forced it upon my entire family to watch and digest, and it has brought us closer together.

Jack Sullivan, 21, Kingston, Ontario, student

THE WEST WING CHANGED WHAT WE WATCH

It's like there was a space in my head just waiting for the perfect show, and there it was, and it lives there. I'm British, so I come with a certain amount of built-in cynicism, but I get American idealism, and I want it to be true. *The West Wing* taps into that. I just can't imagine watching anything better

> Dave Jones, 45, Taunton, England, software developer

I'm still not a big fan of real world politics, but because of *The West Wing*, I love to watch any movie or TV show with a political setting. I tend to follow those pretty well because *The West Wing* also taught me a lot about how politics work. The cast was superb, so I get really excited whenever a cast member appears in a new movie or show, even if it's a small part like Bradley Whitford in *Saving Mr. Banks* or Richard Schiff in *Man of Steel*. I recommend the show to anyone and everyone I talk TV with, and rarely are they disappointed after they dive in.

> Mark Serratore, 26, Tinley Park, Illinois, baseball marketing

Claire Handscombe

THE WEST WING CHANGED EVERYTHING ABOUT OUR LIVES

TEN WAYS THE WEST WING CHANGED ME
by Tom Bigglestone

I was first introduced to *The West Wing* in the front room of a friend's house. It was mid-2008, and I was on the eve of my teacher-training year. I often met with him and another friend for pizza, television, video games, movies, and the occasional venture out into the limited nightlife of our small English medieval city. It was the other friend who was full of beans about this show, which had started about a decade previously and had since finished. I wasn't usually into his tastes, but I thought I'd give it a chance.

I remember enjoying the first episode, but not being particularly bowled over. I'm naturally slow to warm to anything recommended by others. As with music and literature, I like to discover new things for myself and develop my own connection, rather than go on a recommendation. But within days, I had found the first half of the first series of *The West Wing* on my television's on-demand catch up player and was getting through them at a rate of knots. A few days later, I'd ordered the entire seven series, and my mouth was watering at the prospect of having so many episodes to watch for the first time.

I watched at least an episode each working night during

my teacher-training year. It was my reward after my long and tough days as a rookie trainee in front of demanding and often disobedient audiences. My mornings were early and dark, and the nights were drawing in as soon as the last lesson finished. To curl up in bed and watch an episode of *The West Wing* allowed me to see someone *else* work hard and enjoy the various strands of storyline weave together like the most complex of spider's webs. These episodes accompanied me on long train journeys from where I lived in Durham, in the north of England, to where my partner lived in London. It wasn't long before I had finished the entire seven series and was watching again, but I could still while away a three-hour train ride, transfixed by episodes I'd already seen.

It's now over six years later, and whilst I no longer watch *The West Wing* every day, I manage at least an episode a week, on average. Sometimes it's several episodes a day if I've a lot of jobs to do. All on the same, clunky old laptop I had back then. I've gone through the entire set of seasons at least five times and probably double that for seasons One to Four and Seven. And it still feels fresh. But what has been the impact? Here are ten ways it has changed my life:

1. It has increased my ability to work

I've always been one of those who find it hard to work without something in the background, whether it is music, radio, or television. *The West Wing* has always been my distraction of choice. It makes any task bearable. Whether this is spending hours planning lessons, marking assessments, or cleaning the house, having *The West Wing* in the background allows my mind to share its focus between business and leisure.

The West Wing brings an office to me. The office I would like to work in. If I've got *The West Wing* on in the background, I can hear the sounds of my dream office. I can hear the voices of my dream colleagues. They are working long, hard hours. So can I.

2. It provides a unique sense of community

I've seen these episodes so many times now that I very rarely ever sit down and just watch. I know each storyline well and each character so clearly that nothing can really surprise me anymore. I know each major character like they are my friends—the kind of friends I want to have. Characters of strong morality and integrity with whom I'd want to socialise. As a result, I don't feel alone when I'm in the house on my own, and it's on in the background.

3. It redefined my dress sense

I enjoy shopping for, and wearing formal attire. As a teacher, I spend most of my day in a shirt and tie. When buying anything new, I think to myself, "Would Josh/Toby/Sam/Bartlet wear this?" (Leo is a little too old-man for me.) Although their clothes are steeped in late '90s formal dress—lots of pastels, greys, and an alarming amount of navy and burgundy—it still feels timeless. Someone at work last year noticed that I dressed like Josh. Mission accomplished.

Oh, and I own a "Lyman Seaborn 2016" t-shirt.

4. It reinforced my love of dark rooms and soft lighting

I've always preferred soft lighting to harsh office illumination. It is only when I see pictures from the real White House that I realise how dark Bartlet's is. The windows are heavily curtained; there is rarely a main

room light on, with ornate lamps providing everything that is needed. Combined with warm cinematography, this creates a homely, comforting atmosphere to this place of work. There is not a bright fluorescent light in sight, and all of this, combined with deep magnolia and terracotta walls and warm cinematography, make me feel less alone in my dislike of bright bulbs.

5. It has had a major influence on my "work-voice"

I'd like to think my teacher persona is a combination of a lot of things, primarily former mentors and characters from Bartlet's White House. I feel empowered by being able to cherry-pick aspects of the characters to suit situations. If I need to show very little emotion and act in a robotic and quiet manner, I channel Toby's dour and understated side. If I need to show a bit of intellectual spark, it's Bartlet in full professorial mode. If I need to show energy for a cause, yet maintain a disaffected cynicism with the system, Josh is perfect.

6. It ignited my interest in US politics

I follow US politics as much as I do British politics as a result of *The West Wing*. It is not, however, the everyday workings of it, but the election process that fascinates me. I find it interesting to what extent good oratory, looks, and PR are needed for a politician to get elected. Although Season Seven is nowhere near the standard of the first four, the fact it is for the most part an election campaign makes it irresistible.

7. It enabled me to teach about politics

I teach a range of subjects—I'm Head of Religious Education and Philosophy but also teach, or have taught,

History, Geography, English and Physical Education. In all of these subjects, I can drop in references to politics and political systems, and most rewardingly, in Personal Social Health Education—which I teach to my form group—we have a whole unit on politics. Other teachers dread it. I become Bartlet in it.

8. It inspired me to visit the USA

My first time in the USA was a trip to Washington, DC. I spent a week in the capital soaking up the atmosphere with the friend who had introduced to me *The West Wing*. We were in a hostel full of interns, became embroiled in debates with a couple of self-described "raging libertarians", and observed the Obamacare marches outside of the Supreme Court!

9. It decorates my walls

The friend who introduced me to the show, and with whom I visited Washington, DC, made me a carbon copy "Bartlet for America" poster using his highly developed graphic-design skills. He had spotted it in the background of the first episode of Season Two in the flashback to the embryonic campaign headquarters. This poster now hangs proudly in my office.

10. It has relieved my insecurity about my receding hairline

... and its resulting middle-age curls. I'm 28. But hey, if it looks okay on Josh, I'd like to think it looks okay on me.

Claire Handscombe

———— WW ————

How to be a **West Wing** Fan
by Claire Handscombe

Listen to your friends.

Listen to your friends when they tell you there is this programme you should watch because it's about politics and you would like it. Listen to them even though you don't remotely care about American politics and can never remember which party is which.

Borrow a laptop. Maybe yours is broken, or the speakers are not working, or something. The reason is irrelevant and utterly forgettable. You want to watch *Friends*: a few moments of levity in your crazy busy London life before you turn out the lights. Eject the DVD that is in the drive. Note that the DVD you have ejected is, in fact, this other American TV show that your friends won't shut up about, even though your friends, like you, are British, and they don't care about politics of any kind, as far as you can tell, or at least not as much as you do, or did, back in the days when you did.

Forget about *Friends*, or whatever else it was that you were going to watch that night. Instead, give in. Give in, even though American English hurts your ears, and you have to listen hard to understand when they speak fast—which, as it turns out, on this show is always. You secretly think this is because your first language is not English of any kind. Your French mother can never understand American accents and this is one of the many traits you

97

find yourself sharing with her.

Note that this TV show actually seems quite good. It seems intelligent. That is something you did not expect from TV, from American TV in particular. It also features a number of good-looking men, which you probably should have expected but nonetheless pleasantly surprises you. Yes, the dialogue is fast, and you keep having to rewind to catch the words, but later you will learn to use the subtitles to make sure you understand and that will help a great deal. The dialogue is witty. The dialogue seems to have content. Watching feels like biting into a gourmet burger, the kind that is lovingly prepared in a smart Washington restaurant: substantial, satisfying. Not the kind you get in McDonald's, which leaves you wanting something tastier, something healthier, something *more*. One day, not too long from now, you will compare all other TV shows to these kinds of burgers, even ones that you loved, even *Friends*.

Tell yourself, regretfully, that you don't really have time for a new TV show. (It is only much later that you will realise just how much time, how much energy, this new TV show will take up in your life. Just how many things it will change.) You are busy. You live in London, after all, and in London people fill up their diaries weeks or months in advance. Your job takes up all the hours that church activities don't. The very occasional free evening must be immediately filled with people, because you have not yet discovered, or re-discovered, the joys of a quiet night in with a book or a pad of paper. Or, in fact, a *West Wing* DVD.

Spend a week at your parents' house that summer. Take a friend with you; it's a little quiet otherwise. Also pack a DVD. Because you will have time, there in the

countryside. Your parents go to bed at nine p.m. and even your very sensible, early-to-bed, early-to-rise friend is not ready to sleep at nine p.m. Slip the DVD into the laptop. Watch, in silence. You never do anything in silence. This is something of a milestone. When the episode is finished, your sensible friend whose bedtime has passed will nevertheless ask, "Shall we watch another one?" You won't need to think much, or at all, before you answer her.

Go back to London. Resume life at its usual pace. Fit in the occasional episode of *The West Wing* because now you know that it is worth it. Get stuck on one particular episode where the aforementioned good-looking men are playing basketball in sleeveless shirts. Get stuck, not because you are unwilling to move on from that scene, but because the DVD is scratched, or something. Consider giving up. Your friends tell you not to; your friends tell you to power through. Find a way. Borrow someone else's DVD if you have to.

Move to Belgium. This may appear unrelated to *The West Wing*, but it will give you plenty of time to indulge in what are now your favourite DVDs. If possible, be self-employed—perhaps as a language tutor—building up your business will take some months, and you will therefore have guilt-free swathes of time to fill. (You could, of course, be spending this time marketing yourself, but we'll gloss over that.) Move just before the summer so that the friends you are starting to make, and your old friends too, will promptly up and leave you for four weeks. In Belgium, holidays are a month long and July is the deadest of all the months. Do not buy a TV: you will want to be focussed.

Pick up a pen. In the middle of all this, you will find yourself itching to write again, as you did prolifically in

your childhood and your teens. Aaron Sorkin, the writer of the show, has shown you that French is not the only language in which it is worth writing. English can be elegant. English can be powerful. English can, in the words of one of his characters, raise your heart rate. You recognise the bubbly feeling in the pit of your stomach as inspiration now. Start to write. Write a novel based in DC because, after all, the political world is what inspired you this time around. (Back in your teens, it was, of course, existential angst.) Base it in Brussels, too, since that is where you live. It is where you teach French to a Russian diplomat who looks a little like one of the *West Wing* characters, and one Saturday, walking home from the train station after a lesson with him, the idea will come to you: an American diplomat, learning French, will be one of your main characters. Ditch your real surname, which no-one can spell (and you will later discover Americans can't pronounce) and adopt another one as your pseudonym, one that pays tribute to your inspiration.

Read. Read to absorb the rhythms of good writing. Read about authorly technique. Read about politics. Read a lot about politics; you have so much to learn. Read *The Audacity of Hope* and be horrified when you find out that the US is one of only five countries in the whole entire world that does not provide paid maternity leave. The character in your novel, a Senator, needed an issue to fight for, and here's one she and you can get behind.

Visit the US. Years ago, a childhood friend of yours invited you to New York, and you screwed up your face as if it to say, *why would I want to go to New York?* But now you do. Now that you know there are smart Americans, there are eloquent Americans, there are moderately left-of-centre Americans (whom others, amusingly, call socialists);

now that you need to travel there for research purposes, it's a different story. So visit New York. And when your friend asks if there's anywhere else you'd like to go, and you want to respond in all caps, "WASHINGTON, DC PLEASE", be British about it: "I don't suppose we could maybe…?" You can because it turns out she has relatives there who live not that far away. Relatives who are very hospitable and who will pay for a delicious dinner at Legal Sea Foods, and then take you on a drive around DC in the dark, where the lit-up monuments look just like they do on the TV and take your breath away.

Back home, continue to write your novel. Continue to dream of DC; you have fallen in love. Reach for Google and see, just see, if there is anywhere in DC where you can study creative writing: two birds, one stone. You could be there in time for the presidential election. It would be like living *The West Wing*. You could do some campaigning, and call it research. You could watch the debates at nine p.m. like a normal person, or at least a normal political junkie, and not set your alarm at three a.m. for them because of the time difference. American University will reject you the first time you apply, but like your favourite Sorkin character, you have backbone and determination. Try again until they accept you. Try not to feel too terrible about it. You can write. And if you can't now, hopefully you will be able to by the time you graduate.

Dither and do some soul-searching. This is not nothing, this move. It will cost money. It will mean uprooting your life. Losing your language students. Having, yet again, to make new friends. It is a risk. You have upped and moved across seas before; a slightly larger ocean shouldn't scare you that much. And yet, somehow, it does: the unknown.

Listen to your friends. They have been right before.

They are right now, when they tell you that you should just do it. *Okay*, you say, *okay*, and later you will wonder why you ever hesitated at all.

You will wonder this on many occasions. You will wonder this when you get to meet your favourite actors—he of the bare arms, for example, though now all dressed up in a tuxedo and wearing it extremely well. You will wonder this when you sit in rapt attention as your young and handsome speechwriting professor tells stories that begin "when I was working at the White House…" You will wonder this when the boundary between truth and fiction blurs further, and you find yourself sipping wine on a Hollywood director's boat as some kind of precursor to his Congressional run. You will wonder this when you stop to take your thousandth picture of the Capitol, surrounded by fall colours or springtime bloom. You will wonder this each time you walk past the White House—though walking past is a misnomer. You will be incapable of walking past. Every single time you will stop and look and wonder at its closeness, and that you get to live here, on the set of your favourite TV show, the TV show that has unexpectedly, improbably, changed your life.

But when they ask you, in America, how you ended up there, you will hesitate slightly. You won't want to sound like some kind of weirdo. You won't yet have learned that few people in DC think this odd. That when you go to an interview in a Congresswoman's office and confess to the reason for your interest in politics, your potential future boss will say, "Oh, that's what got me into it, too."

In love with your new life, you will sometimes shake your own head and find yourself wondering: because of a TV show, seriously? Well, yes and no. But mostly yes.

ACKNOWLEDGEMENTS

Thank you to everyone who has been part of this project. First and foremost, to the contributors, without whom there would be no book. There would be no book, either, without the writers, cast, and crew of *The West Wing*, so thank you to each and every one of them for this tremendous gift they have given the world. There may also be no book without Emily Travis Ribeiro, who one night in London lent me a laptop that happened to have a *West Wing* DVD inside it, unwittingly changing the course of my life.

Thank you to my current flatmate, Liz Dawson, for her steadfast support and patience in this and so many other endeavours.

Thank you to my cover designer, Kerry Ellis, and to my copy-editor, Jennifer Bogart Jaquith. This project deserved nothing less than the highest quality, and you brought that to it, and I'm grateful.

And thank you to all of my crowdfunders for being there with your support from the very beginning: Anthony Patronick, Ashley Hansen McCoy, Ben D Odams, Brad Nolan, Bradley S Brown, Chris Goode, Chris Weigert, Cody Palmer, Craig Newmark, David Wood, Dirk Meister, Dorval Wayne West, Erin M Estevez, Fluff Abrahamsson, Jena Yamada, Jennifer Allen, Joanne Burch, John Luteran, J Seargeant, Karen A Veltri, Laura Fleagle, Mary Stewart, Michael M Willett, Nic Schlagman, Patrick Allan, Simon Lavis, S J Taylor-Bryant, Sam, Sarah Trabucchi, Steve

Lambert, Sharon Prionas, Simon Stone, Sonia Faletti, Tom Valentine. Thank you for being excited about this when it was just a glint in my eye! You rock. I'm crowning all of you the Greatest *West Wing* Fans Ever.